LIONS AND TIGERS AND BEARS, OH MY:
(I DON'T DRAW TIGERS)

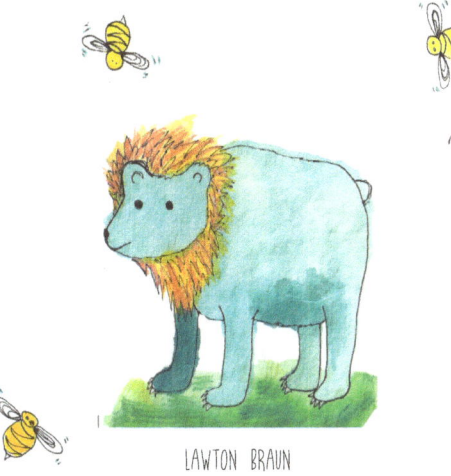

LAWTON BRAUN
COPYRIGHT © 2013 LAWTON BRAUN
ALL RIGHTS RESERVED.
ISBN: 149374836X
ISBN-13: 978-1493748365

LAWTON BRAUN

DEDICATION

TO EVERYONE THAT EVER WAS,
BUT SPECIALLY TO
JOHN ELWAY AND SARAH PALIN

LIONS & TIGERS & BEARS, OH MY

CONTENTS

ACKNOWLEDGMENTS IV

1 COMPUTER PAPER PROJECTS: PG 1

 JENNY HAS † ANSWERS
 GIRL WITH BEAN DIP
 FEELS IN KIDDIE POOL
 CLYDE LICKIN' † OUTLET
 NO TO FIST-O-CUFFS
 STOP BEING A NINNY
 LITTLE CRITTER CARL
 JOHNS & † SHARP FINGERS
 TIMMY WITH † FILED TEETH
 BEARS WATCHIN' BEES

2 WATCHIN' DAT WATERCOLUR PG 12

 MAC & † WELL CRAFTED PENCIL
 TRACE WITH † FEET & HAND WINGS
 † CLYDE & LAWSON SHOW
 BEAR WANTIN' HONEY
 MELANCHOLY HELP FROM CALLEN
 LEONARD & † BEES
 GUSTO & ZEST ARE † BEST
 CHESTER & † BEES

3 FROM BEES MAKE ME NERVOUS: PG 21

 BEES MAKE ME NERVOUS
 TIMMY & † ODD SHAPED HIVES
 JOHNATHAN! † NON-OBSERVANT
 WALT FINDIN' THAT DISGUISE
 BOBBIN' YA HEAD
 TIBS & HIS WINGS

LAWTON BRAUN

ACKNOWLEDGEMENTS

THANKS TO MO FOR MAKIN' ME DO THIS.
THANKS TO CACTUS FOR THE IDEAS AND TITLE HELP.
ALSO PUTTING UP WITH ME. THAT WAS KIND OF YOU.
ECIL AND KAITLYN THANKS FOR CRACKING A SMILE.
ALSO FOR HUMOURING ME, THAT WAS KIND OF YOU.
THANKS TO EVERYONE THAT LAUGHS AT MY WORK.
THANKS TO BUTTER AND BEE'S KNEES.

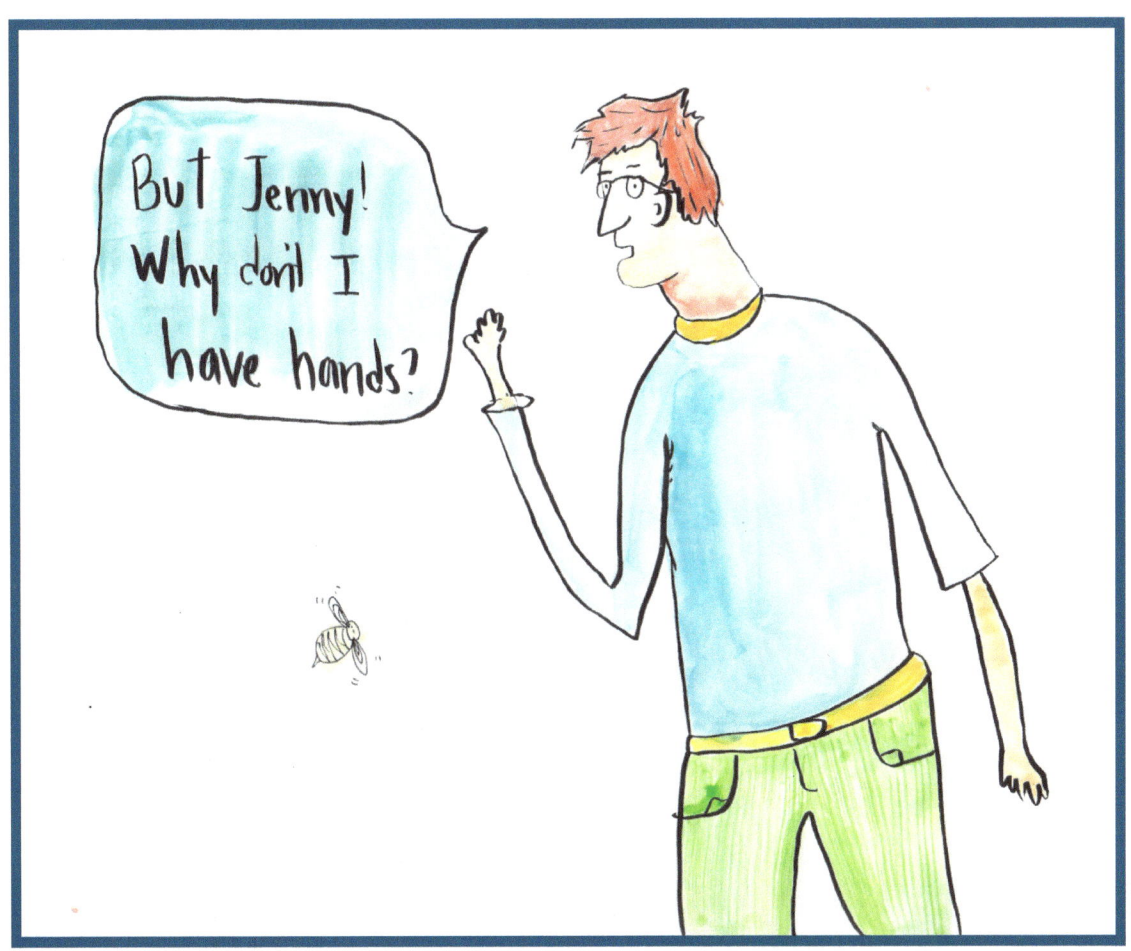

"JENNY HAS THE ANSWERS"

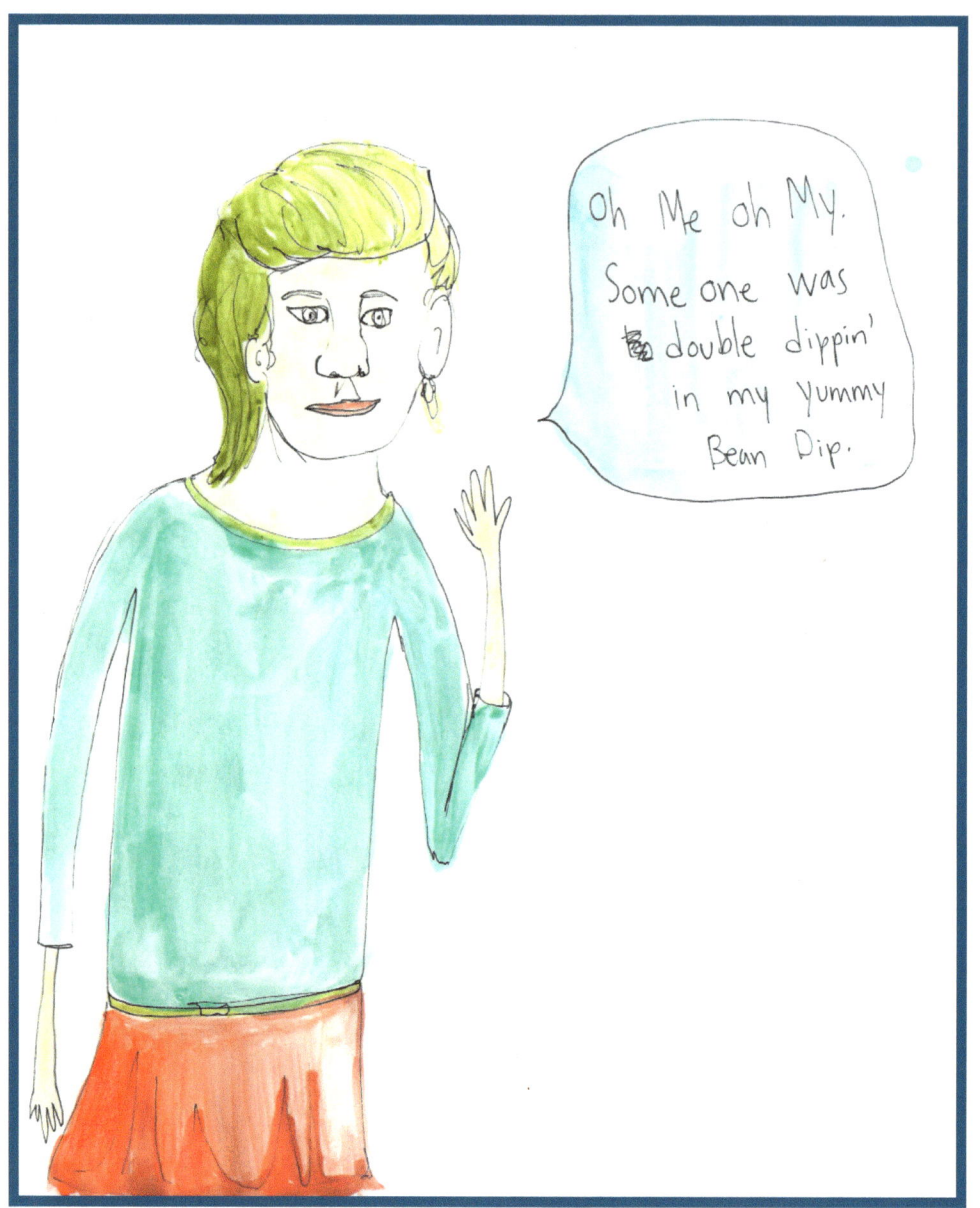

"GIRL WITH BEAN DIP"

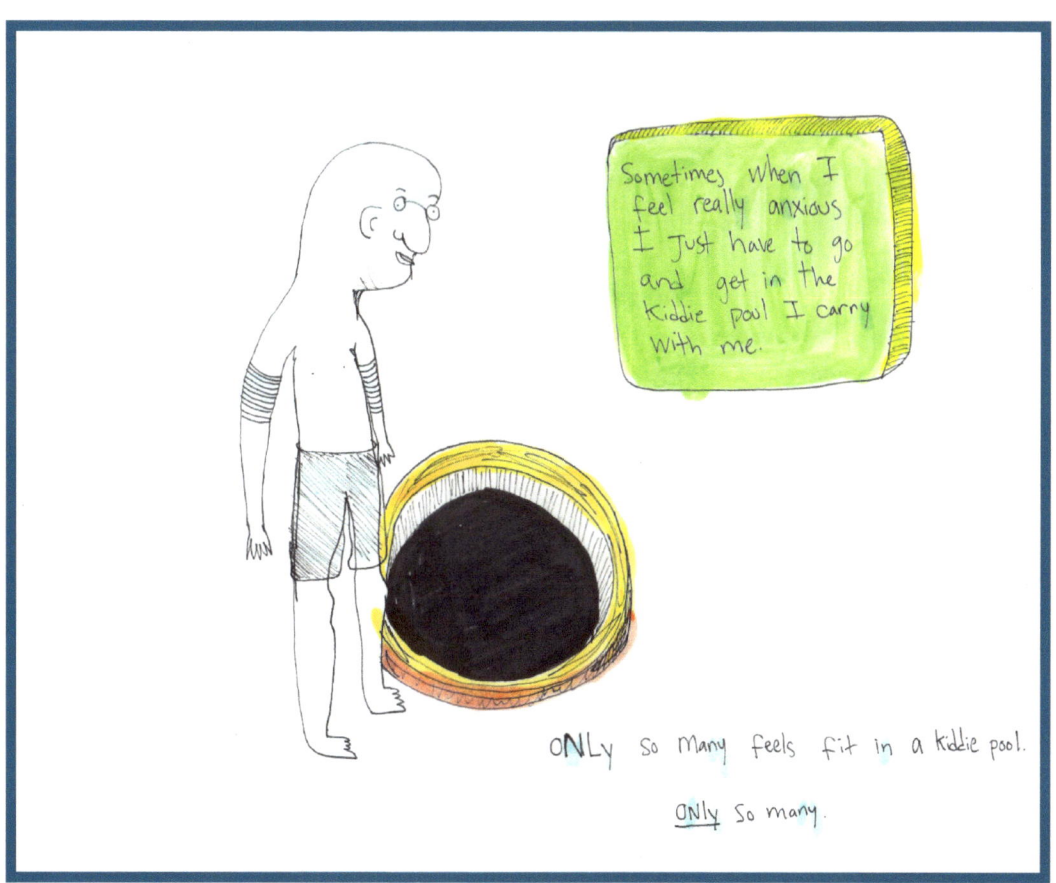

"FEELS IN A KIDDIE POOL"

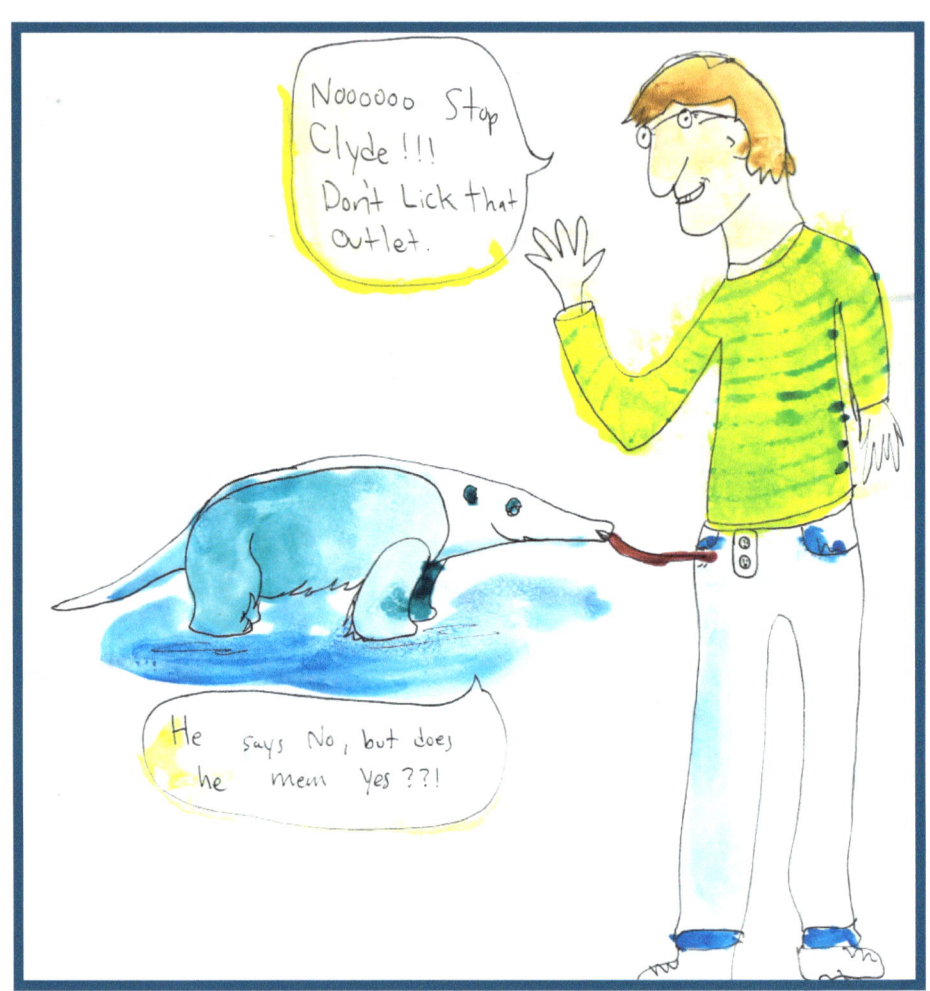

"CLYDE LICKING THE OUTLET"

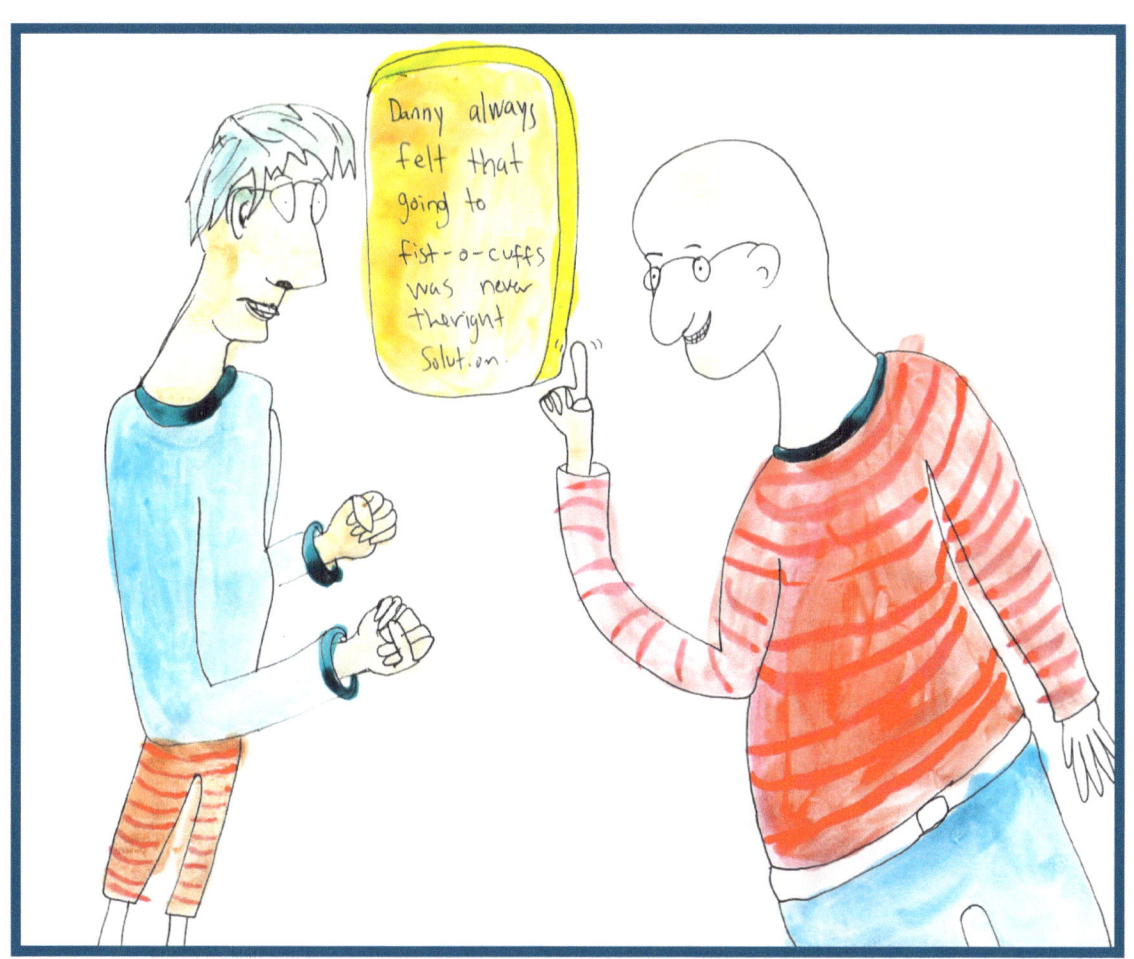

"NO TO FIST-O-CUFFS"

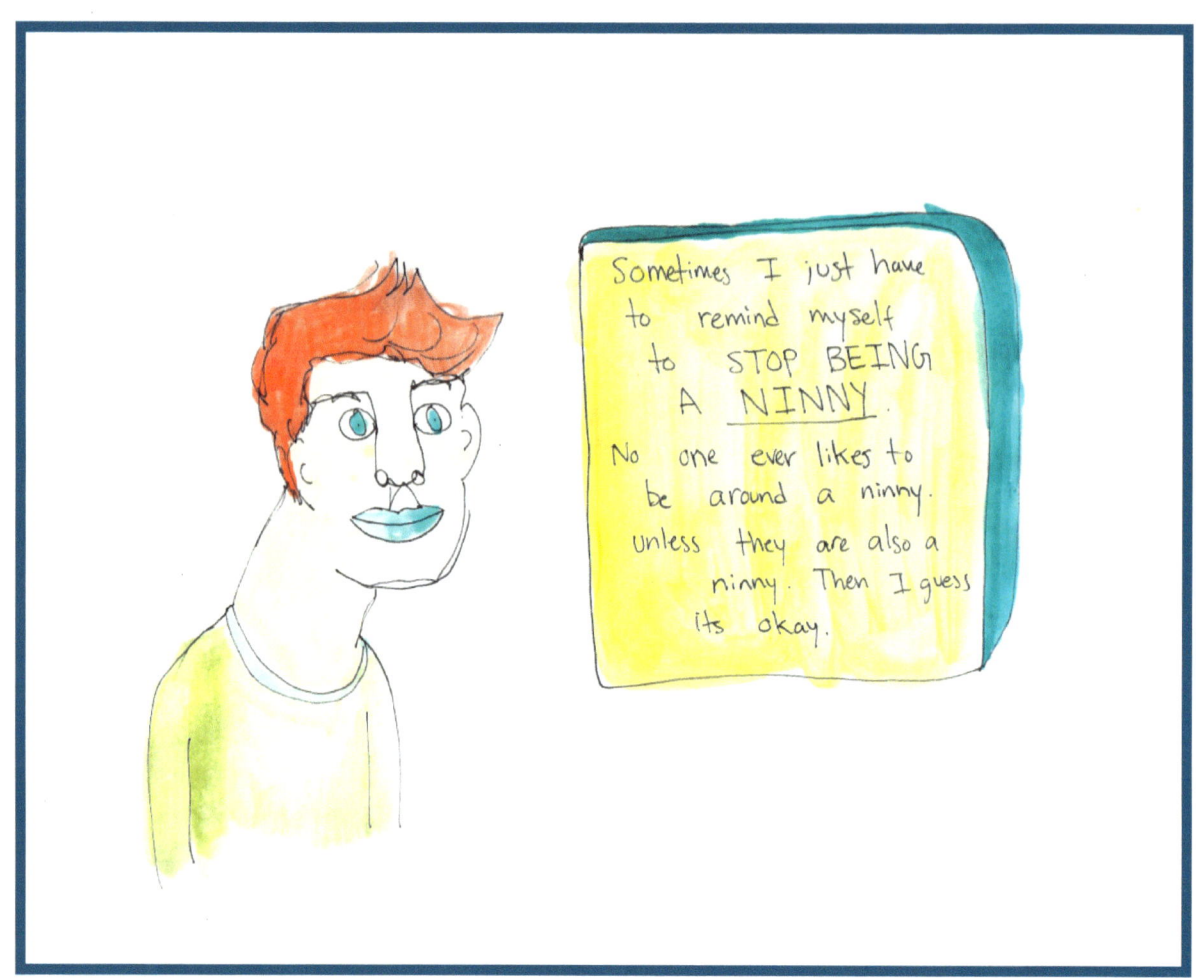

"STOP BEIN' A NINNY"

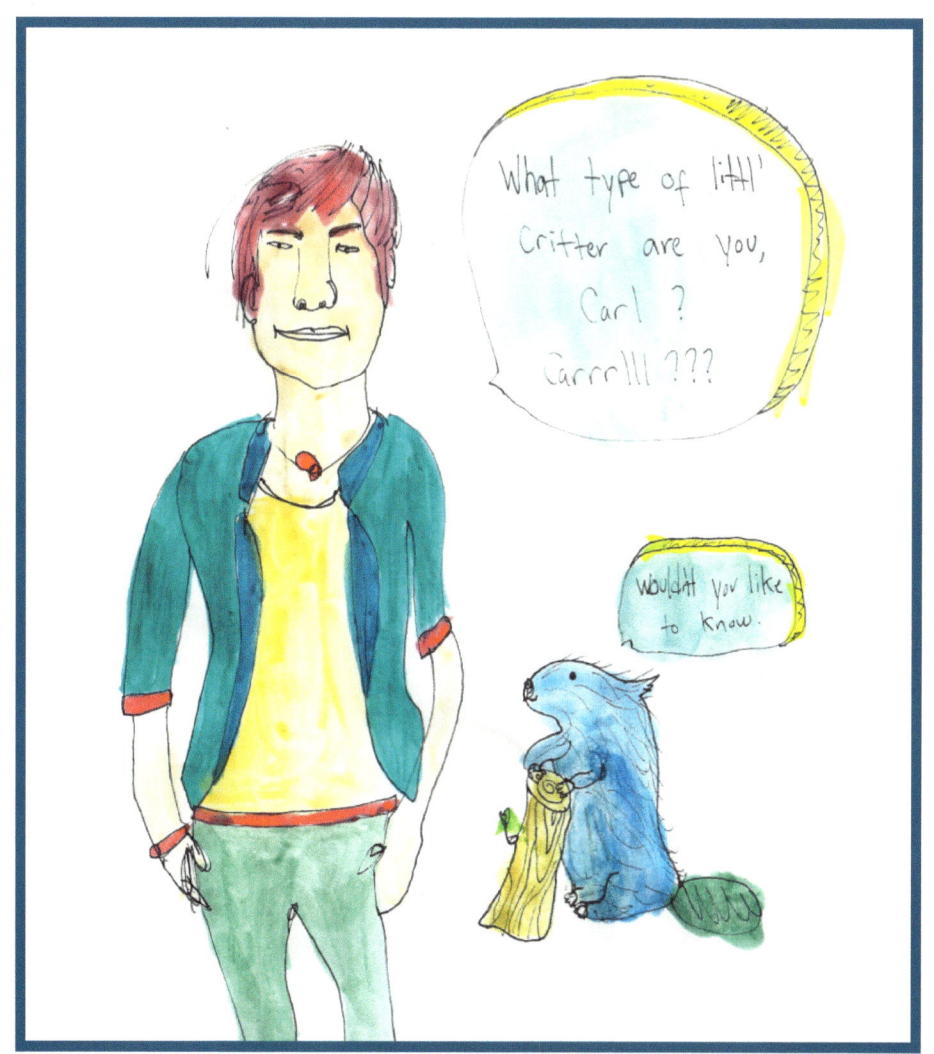

"LITTLE CRITTER CARL"

COMPUTER PAPER PROJECTS

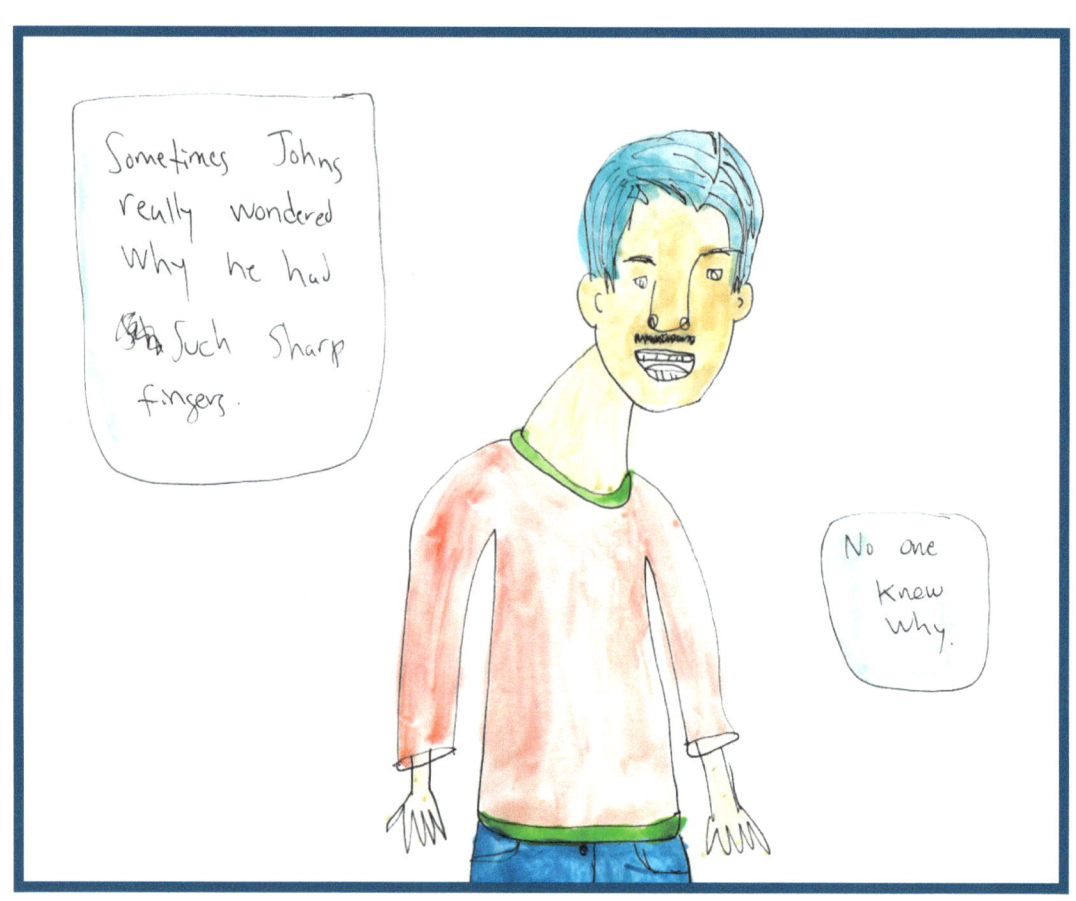

"JOHNS WITH THE SHARP FINGERS"

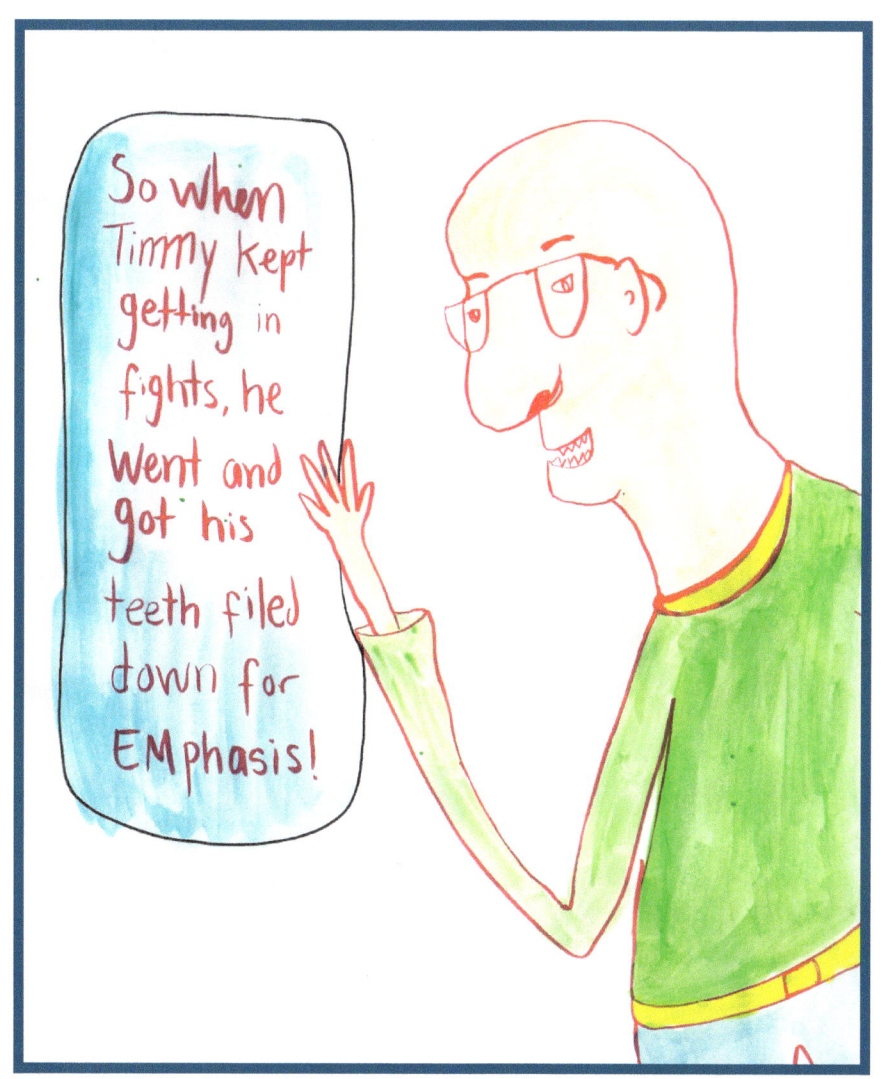

"JENNY HAS THE FILED TEETH"

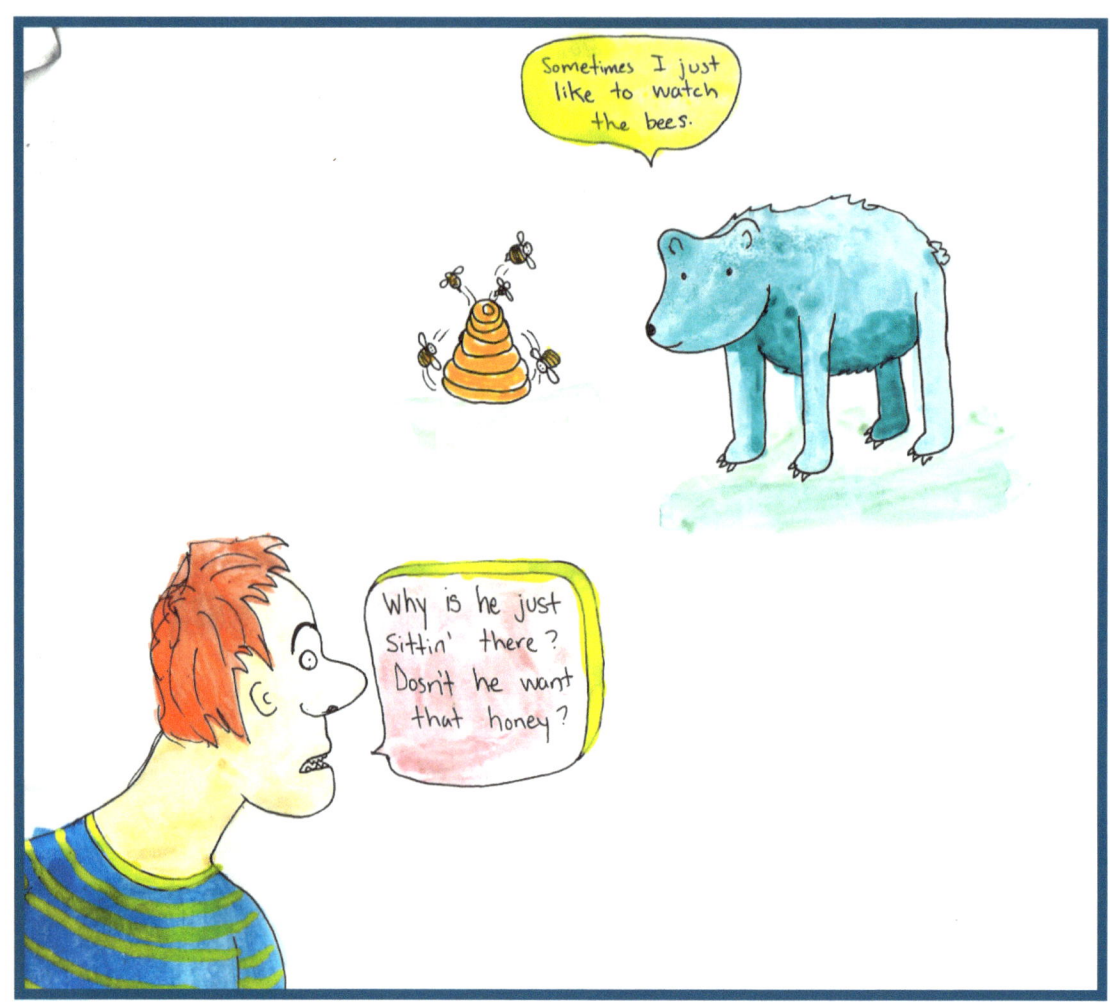

"BEAR WATCHIN' BEES"

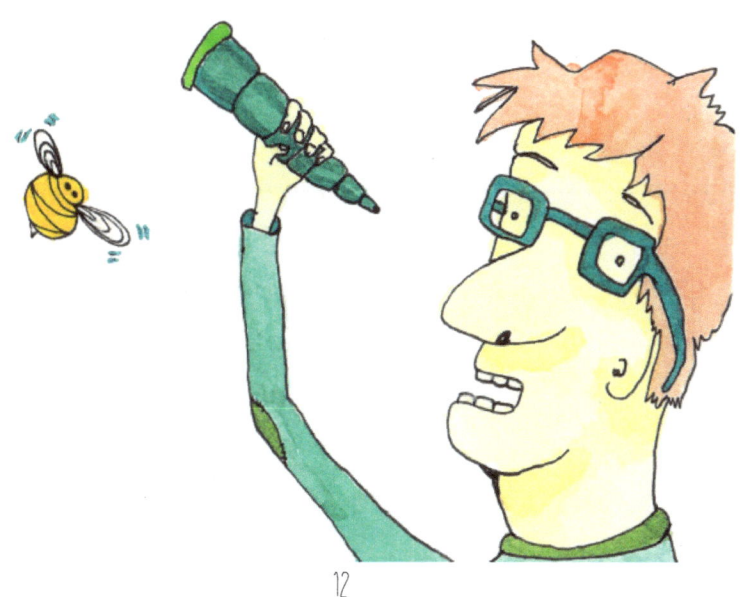

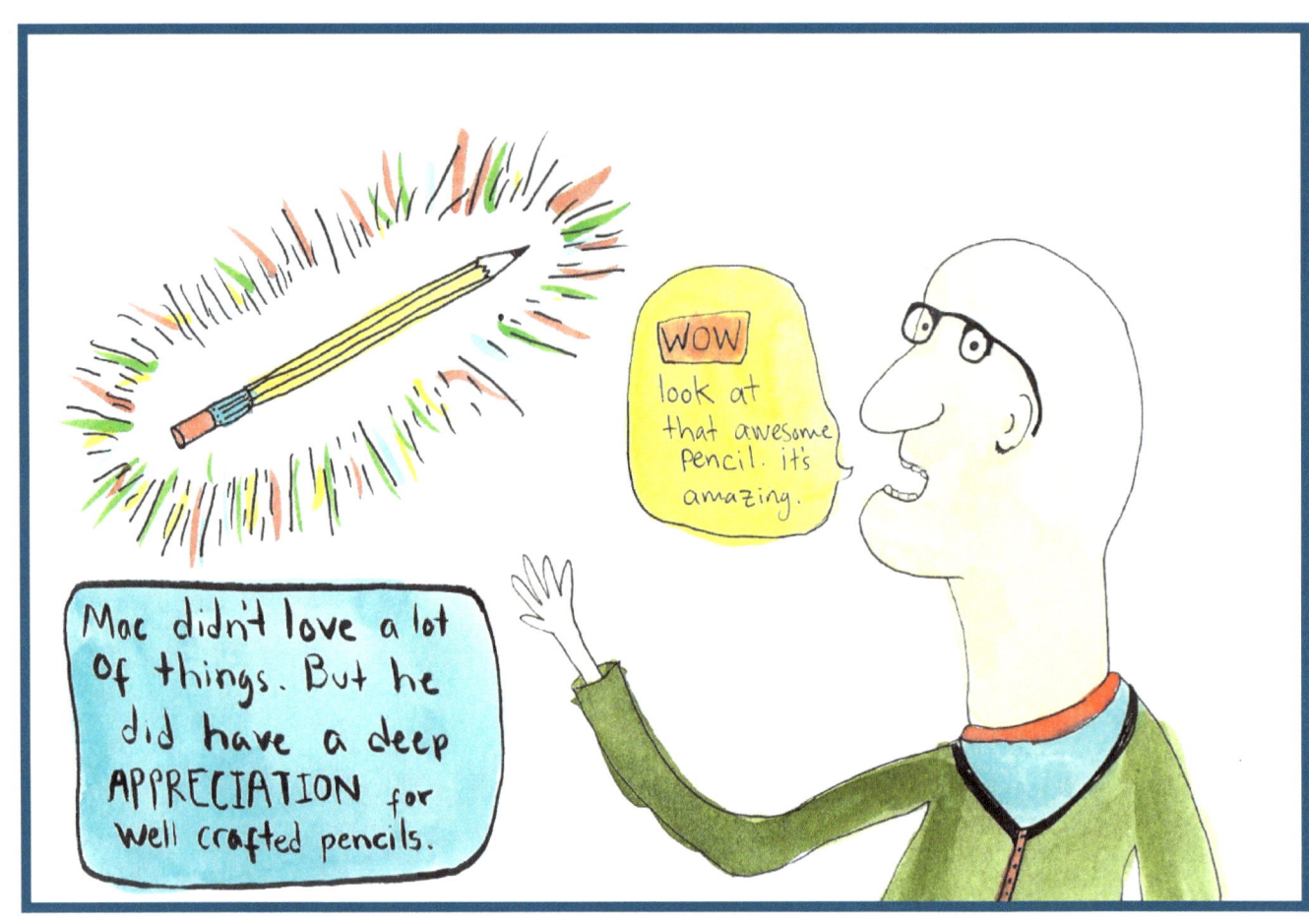

"MAC AND THE WELL CRAFTED PENCIL"

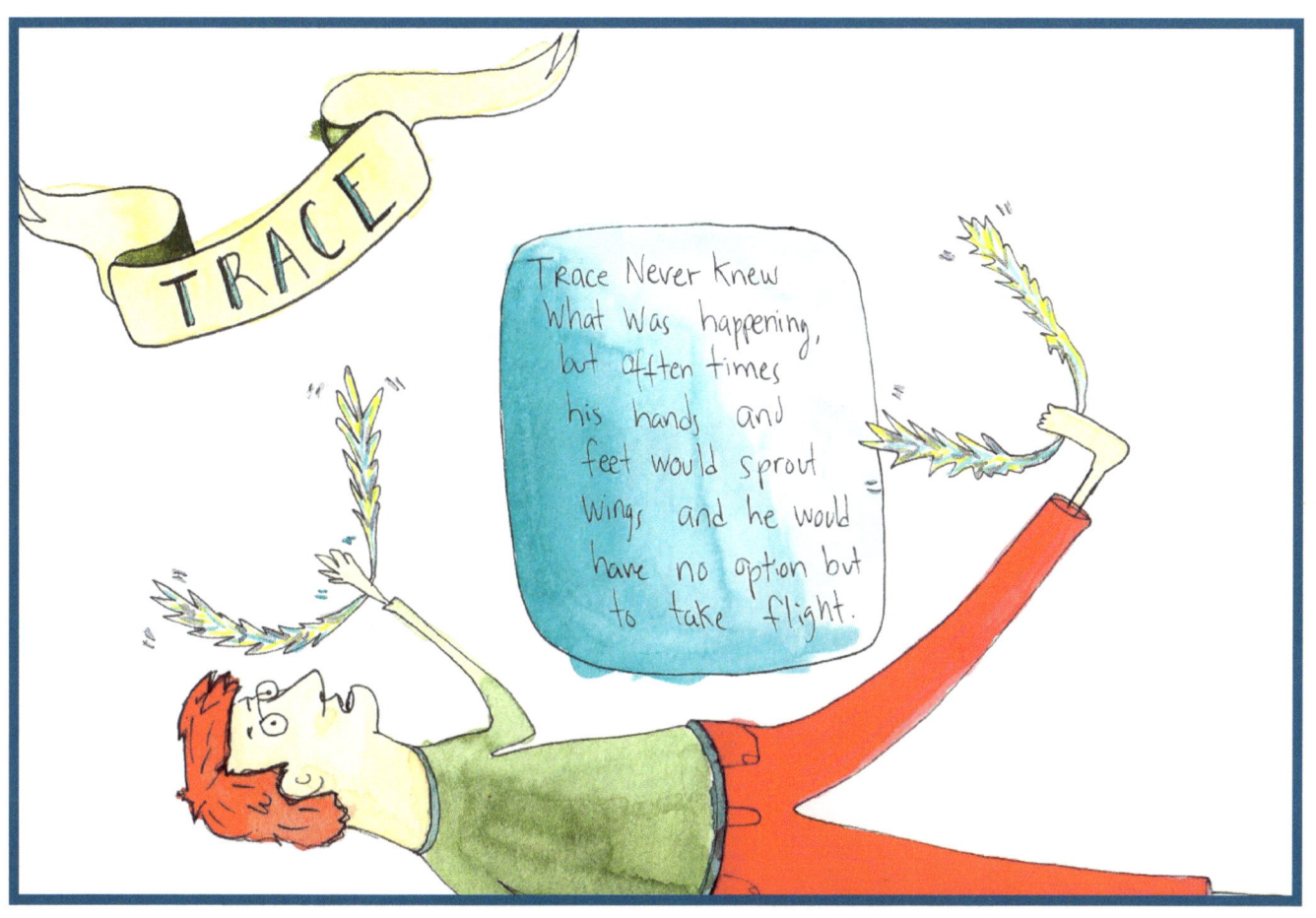

"TRACE WITH THE FEET AND HAND WINGS"

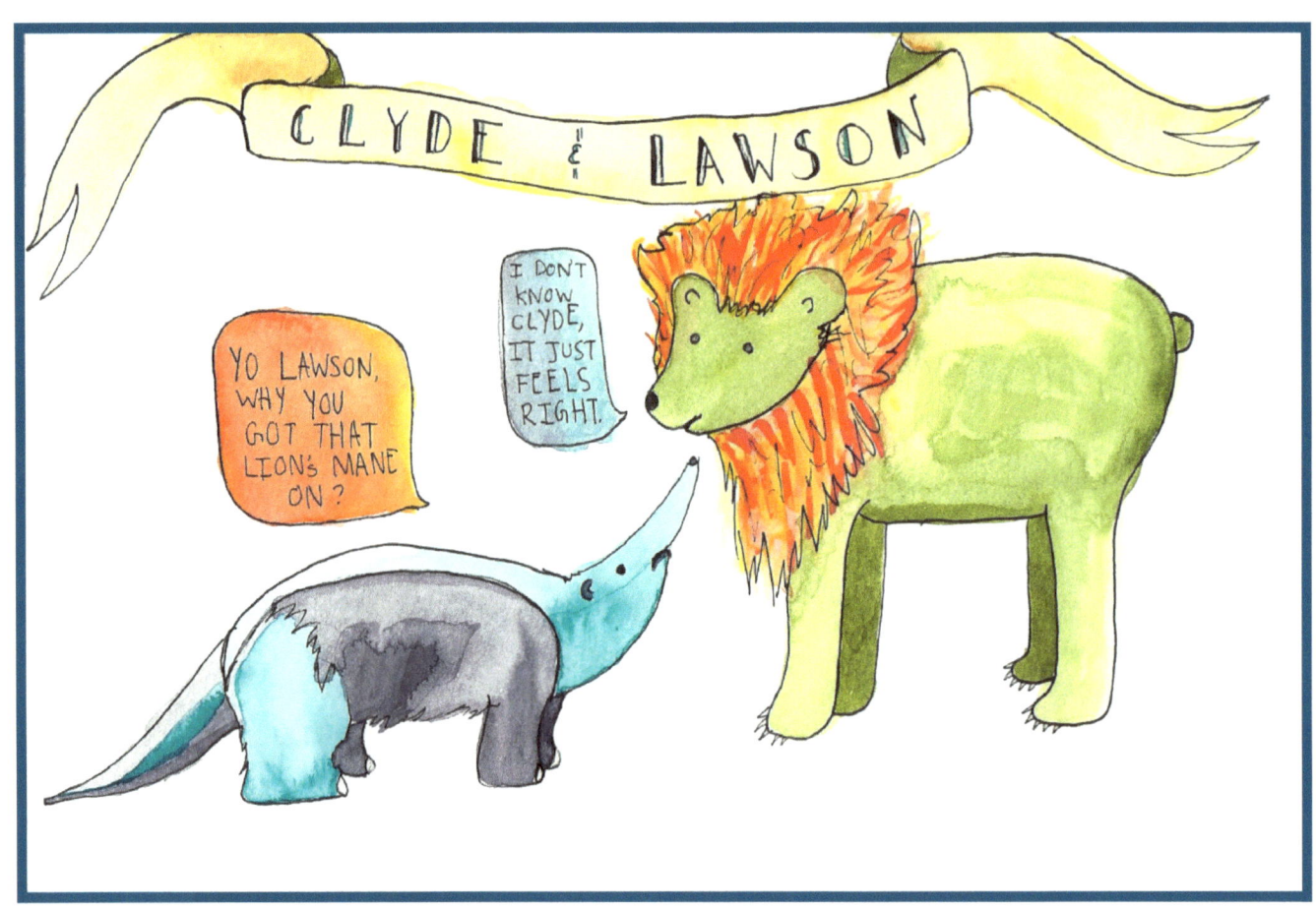

"THE CLYDE AND LAWSON SHOW"

WATCHIN' THAT WATERCOLOUR

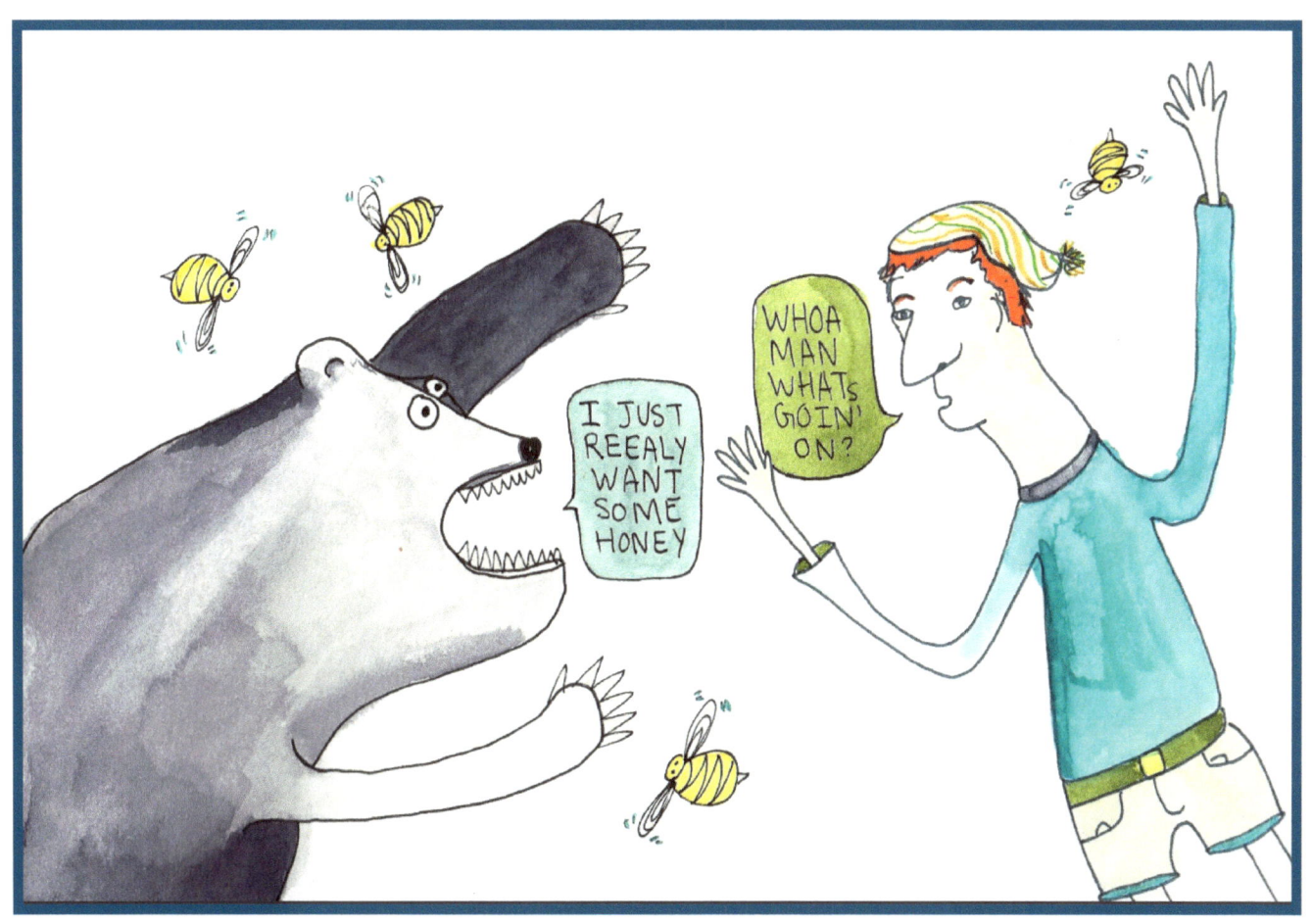

"BEAR WANTIN' HONEY"

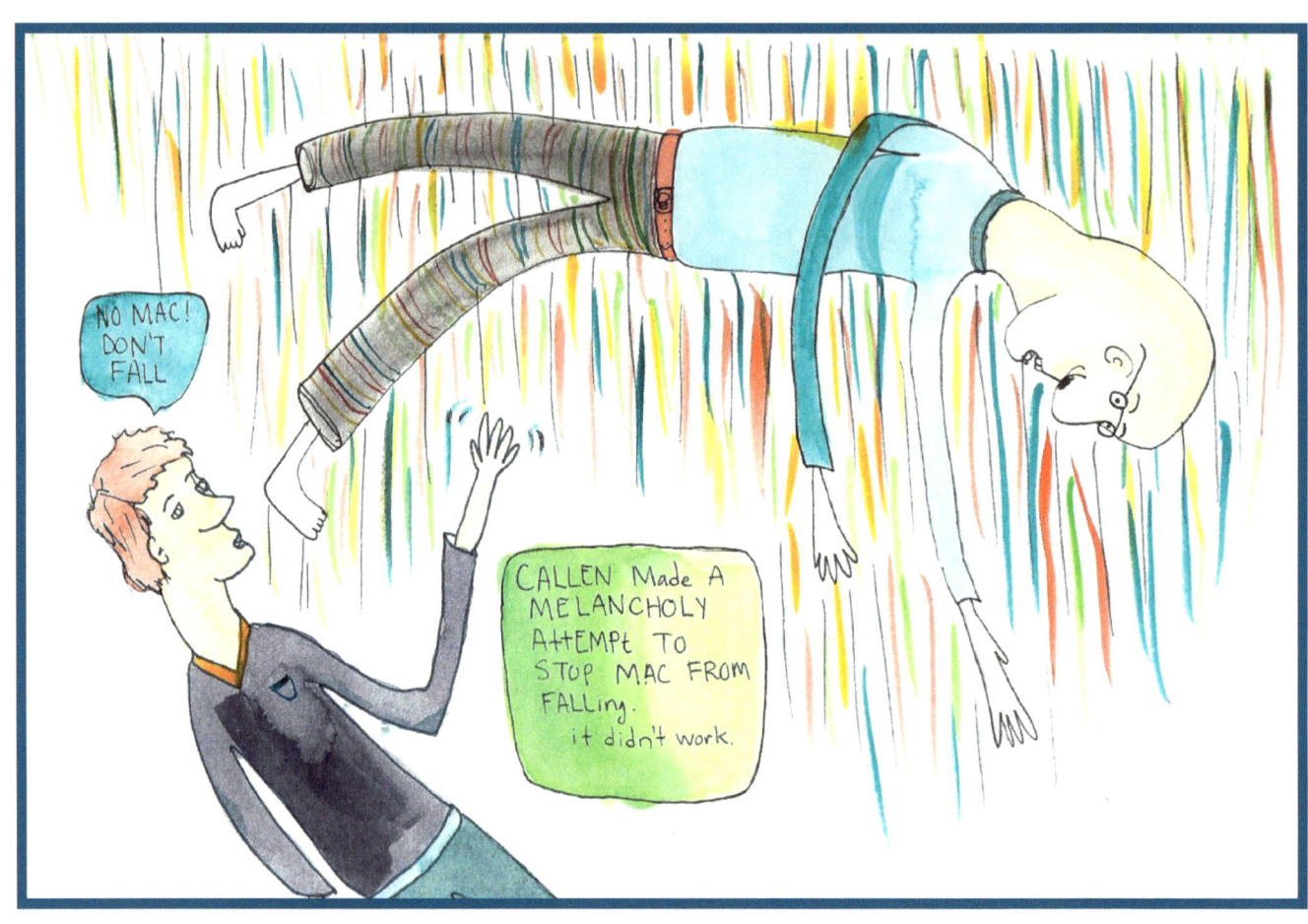

"MELANCHOLY HELP FROM CALLEN"

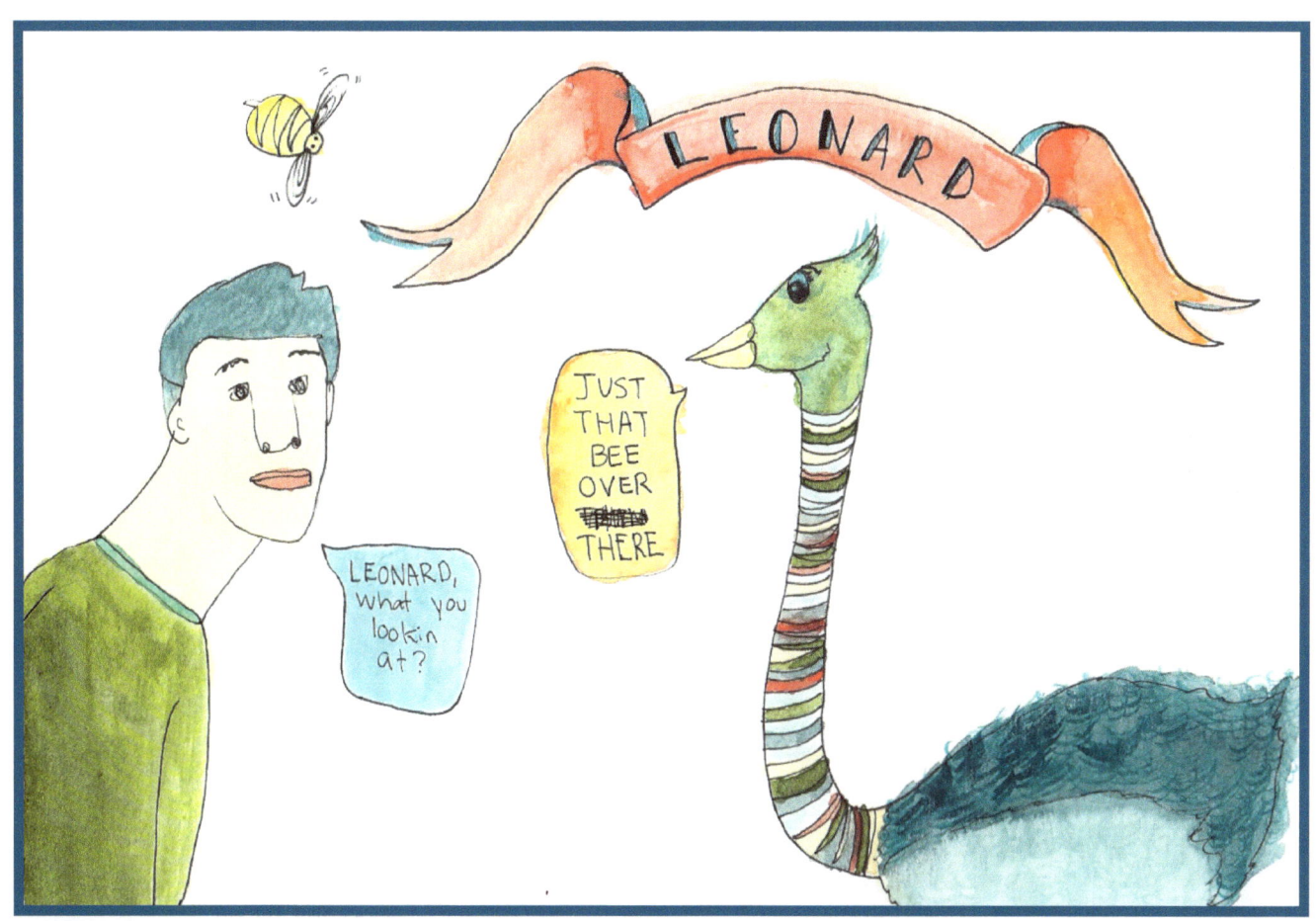

"LEONARD AND THE BEE"

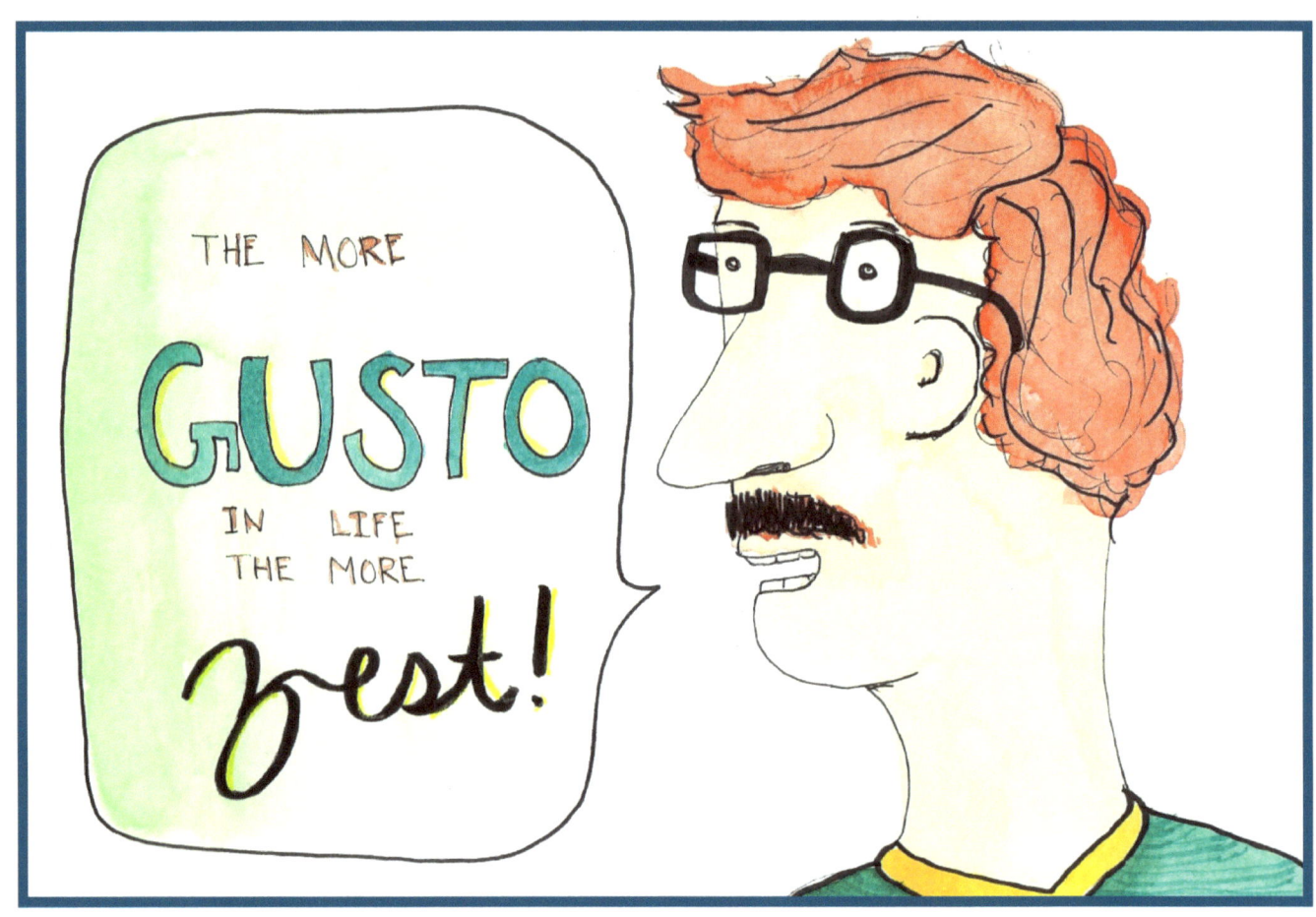

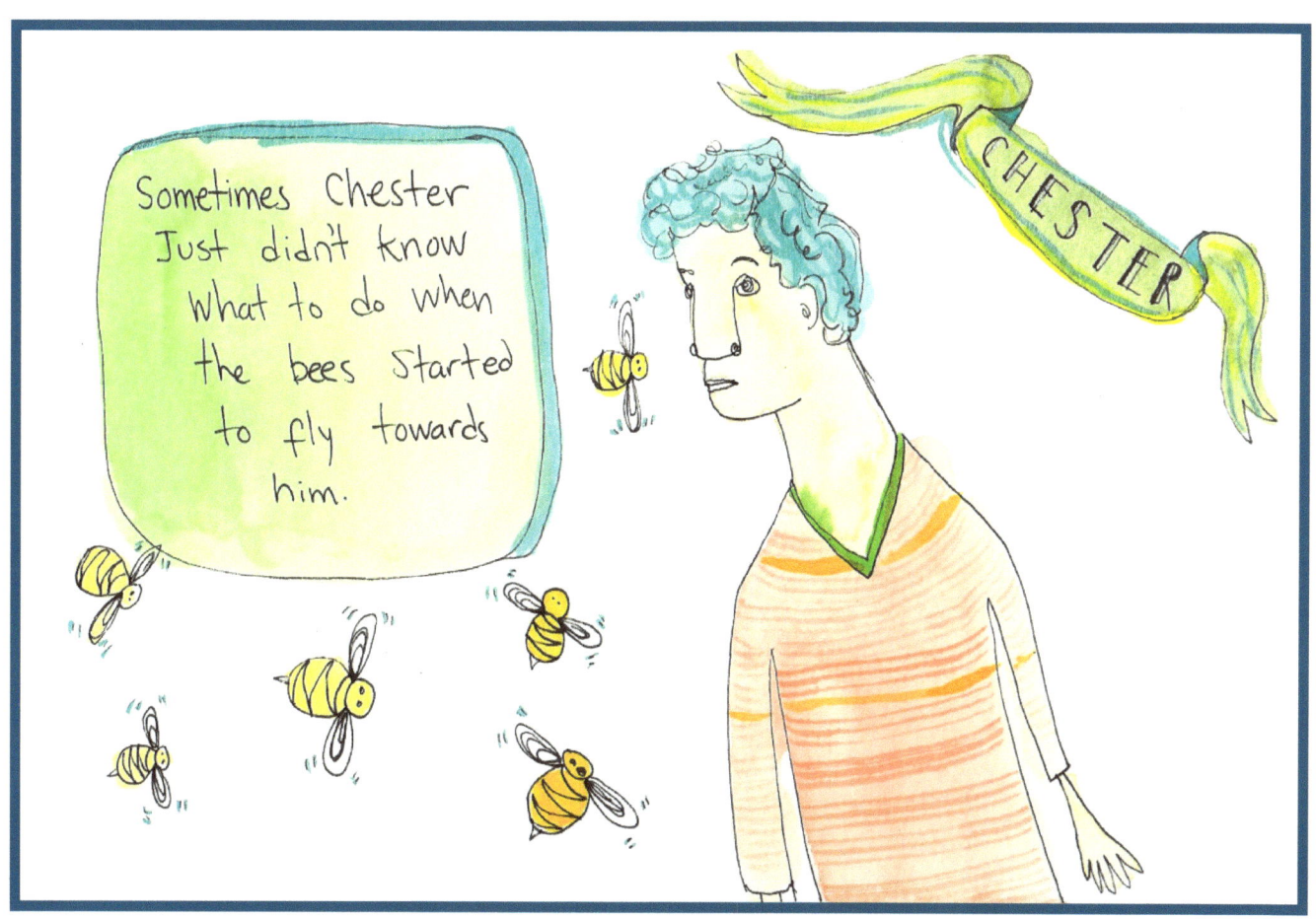

FROM "BEES MAKE ME NERVOUS"

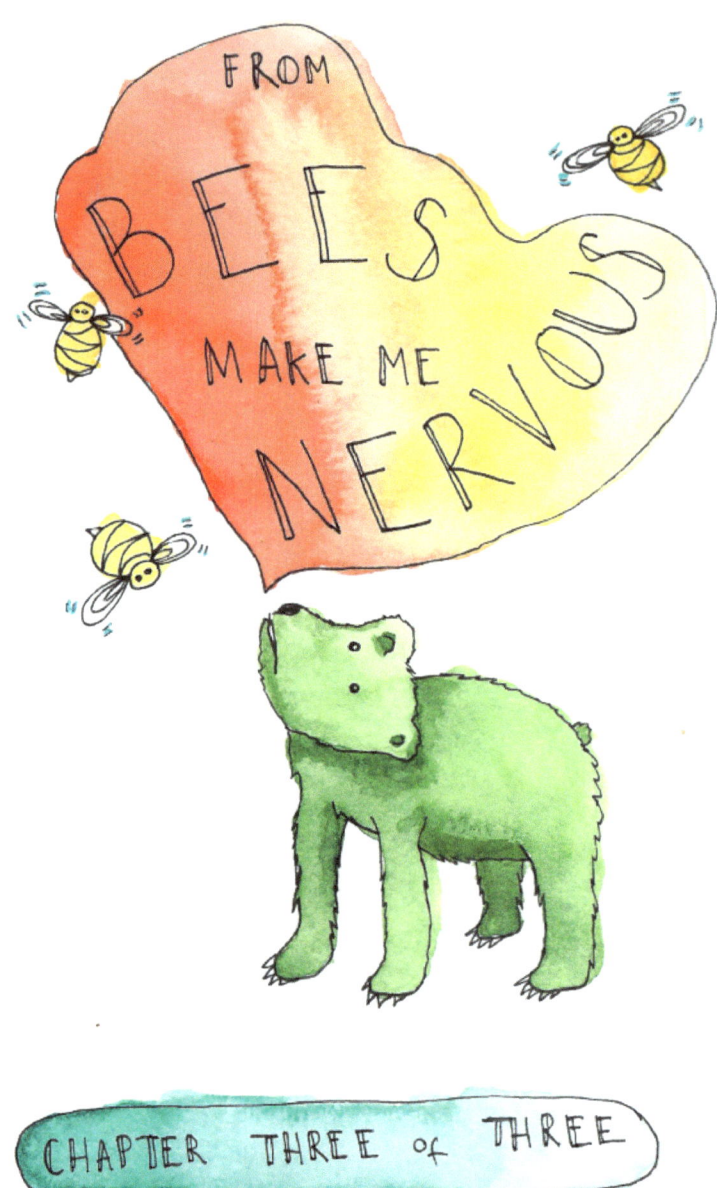

FROM "BEES MAKE ME NERVOUS"

"BEES MAKE ME NERVOUS"

FROM "BEES MAKE ME NERVOUS"

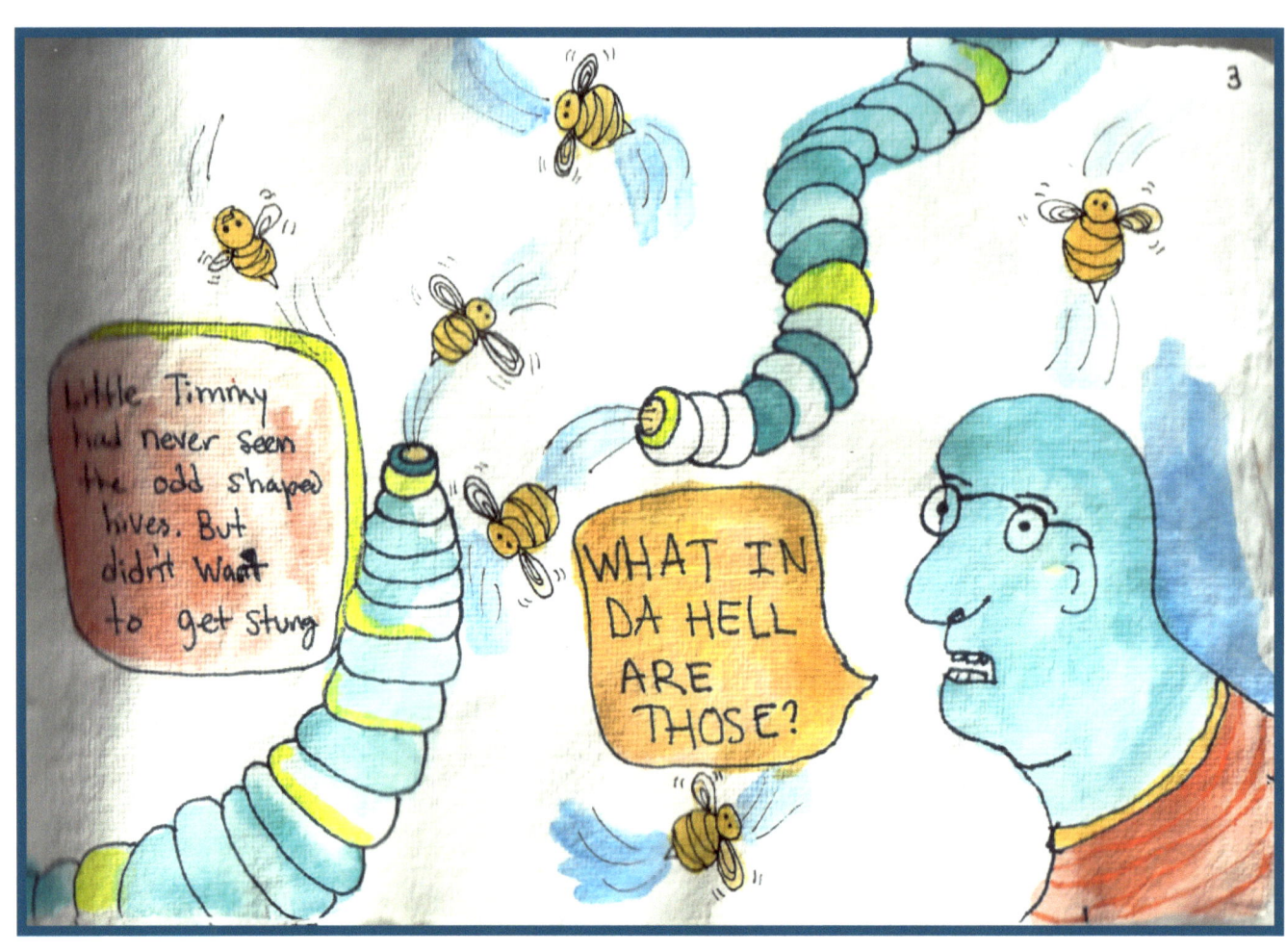

"TIMMY AND THE ODD SHAPED HIVES"

FROM "BEES MAKE ME NERVOUS"

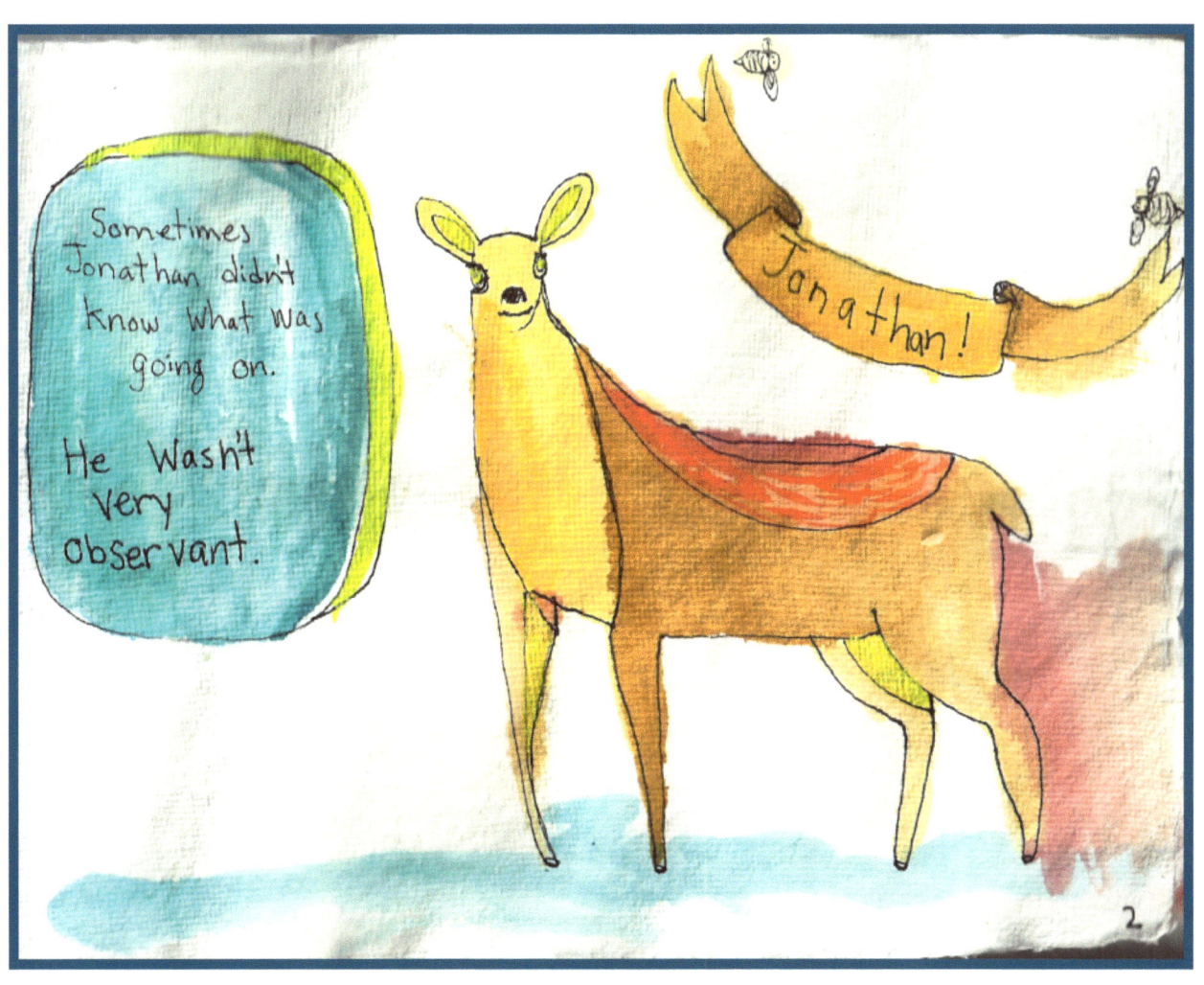

"JONATHAN THE NON-OBSERVANT"

FROM "BEES MAKE ME NERVOUS"

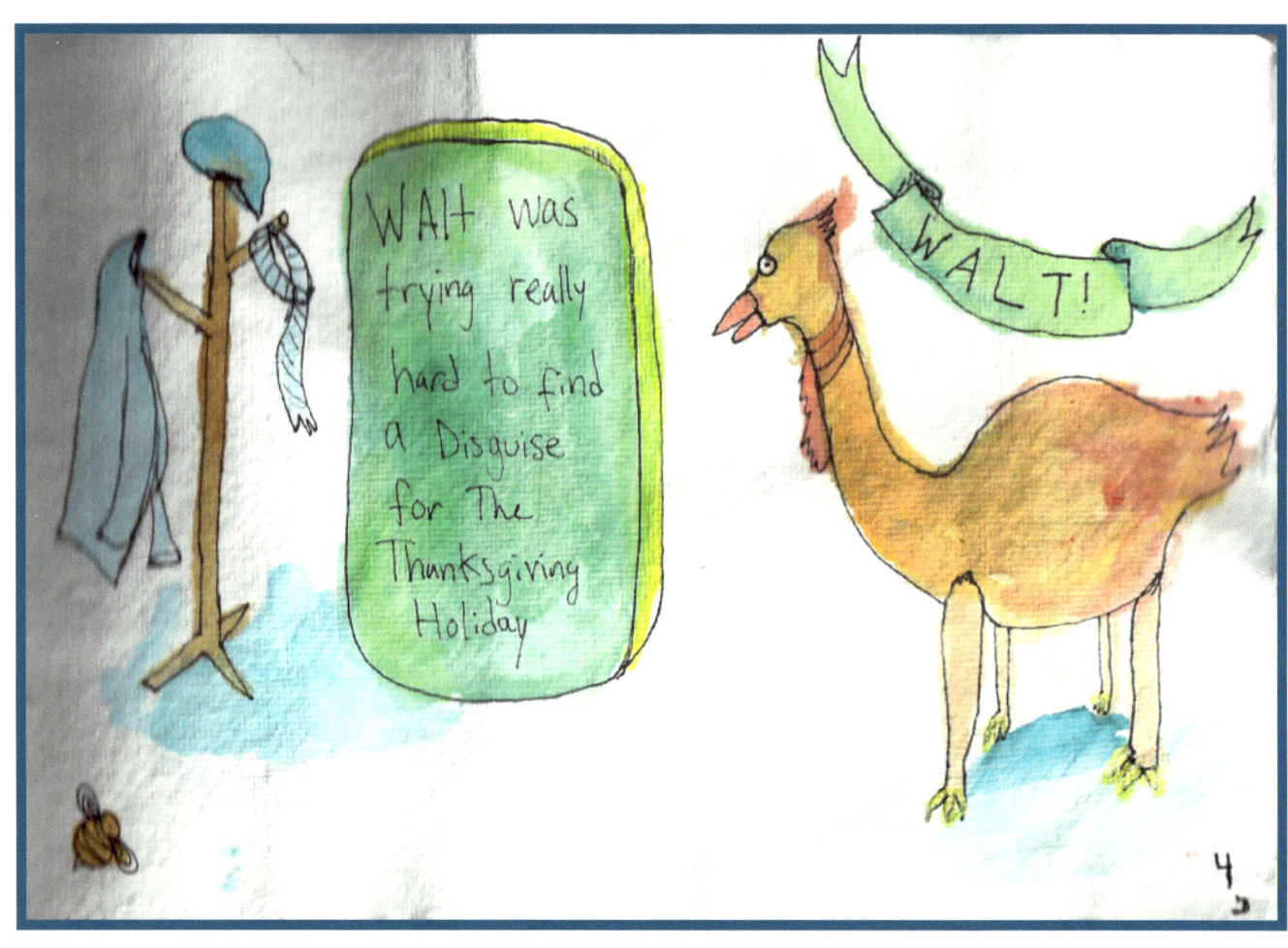

"WALT FINDIN' THAT DISGUISE"

FROM "BEES MAKE ME NERVOUS"

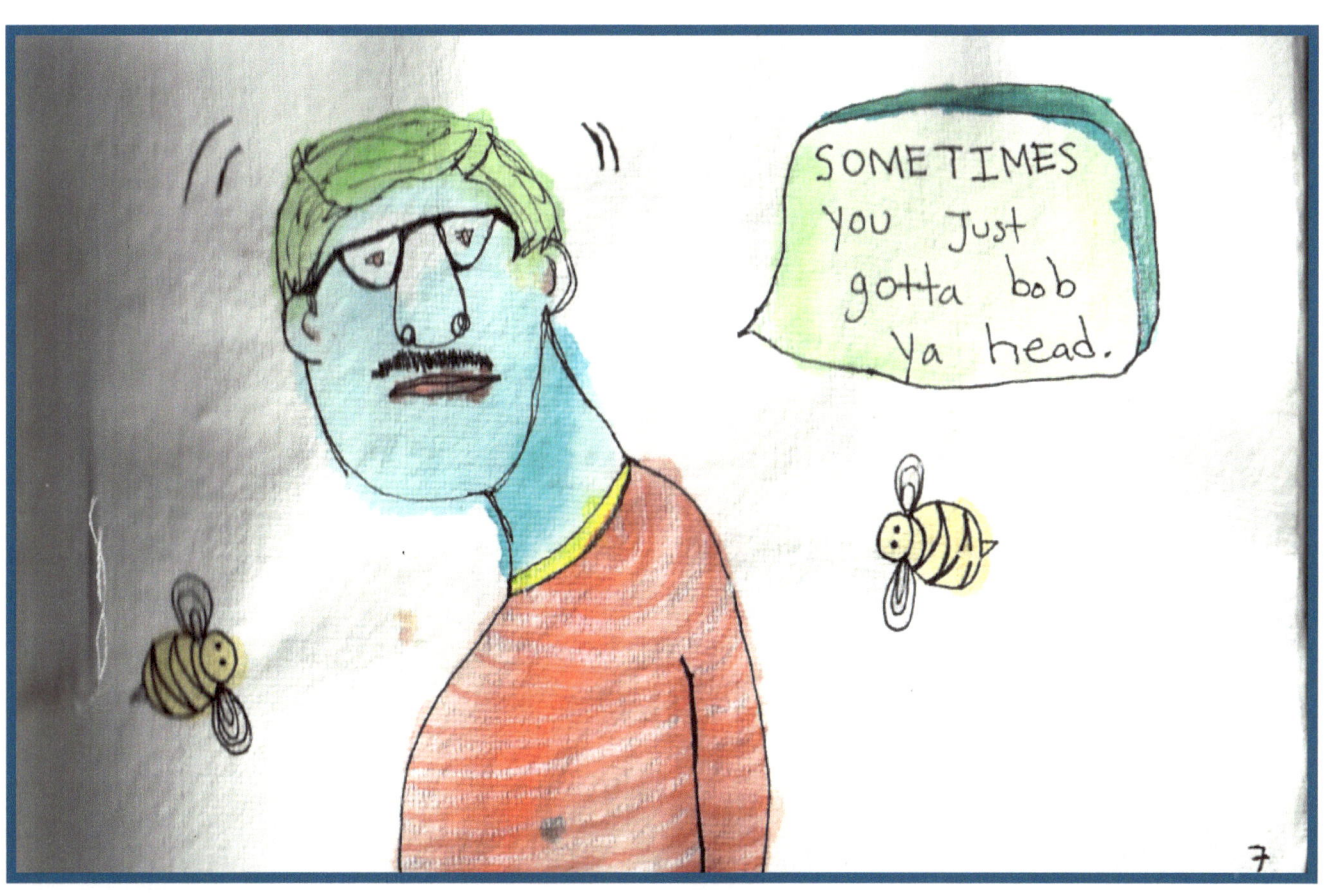

"BOBIN' YA HEAD"

FROM "BEES MAKE ME NERVOUS"

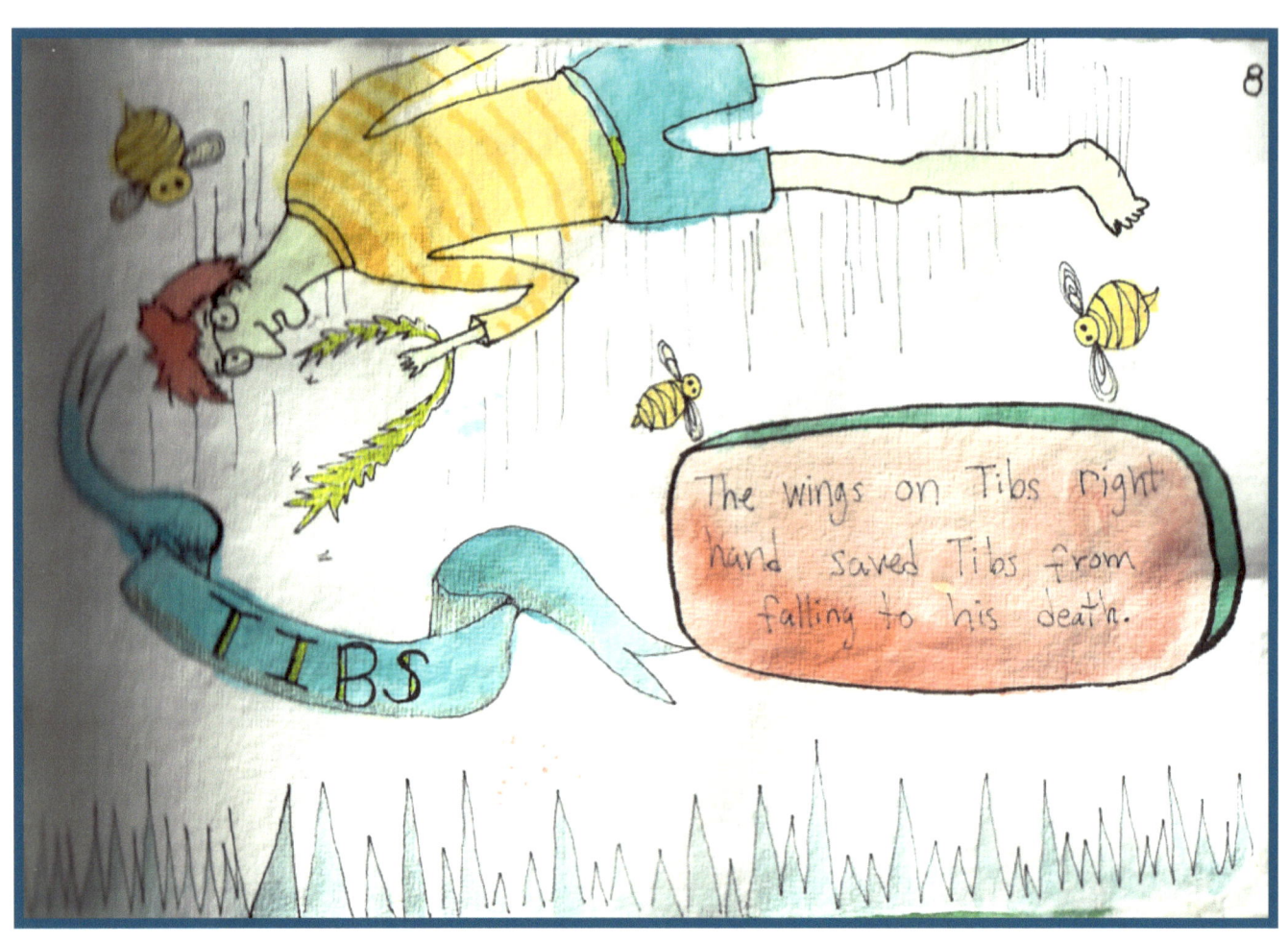

"TIBS AND HIS WINGS"

www.ingramcontent.com/pod-product-compliance
Lightning Source LLC
Chambersburg PA
CBHW050411180526
45159CB00005B/2225